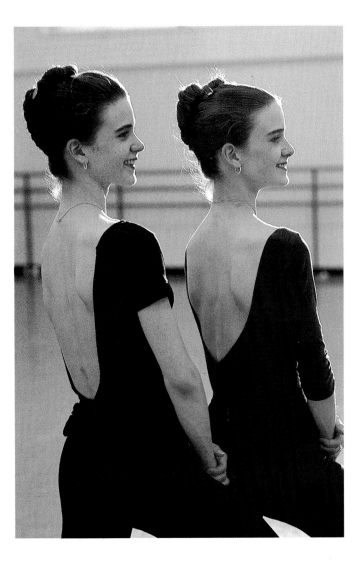

# Twins
# on
# Toes

*A Ballet Debut*

---

*by Joan Anderson*

*photographs by George Ancona*

---

Lodestar Books

*Dutton   New York*

*Acknowledgments*
*It is with much gratitude that we thank the School of American
Ballet for allowing us to become part of the school and its
classes. We are particularly grateful for the counsel of Thomas
Schoff and Nathalie Gleboff, Associate Director of the School.
Finally, it was inspiring to work with such dedicated young
women as Amy and Laurel Foster. Many thanks.*

*The photographs contained in this book that portray the
choreography of George Balanchine are used with permission of
The George Balanchine Trust. The purchase or ownership of this
book conveys no right to reproduce such photographs or to
portray the choreography without the express permission of The
George Balanchine Trust.*

*Library of Congress Cataloging-in-Publication Data*
Anderson, Joan.
Twins on toes: a ballet debut/by Joan Anderson; photographs by
George Ancona.—1st ed.
p.   cm.
Summary: Describes the experiences of twins, Amy and Laurel
Foster, who trained for ten years to become professional ballerinas
and studied at the School of American Ballet.
ISBN 0-525-67415-2
1. Ballerinas—United States—Juvenile literature.   2. Twins—
United States—Juvenile literature.   [1. Ballet dancing. 2. Ballet
dancers.]   I. Ancona, George, ill.   II. Title.
GV1785.5.A53   1993   792.8'09—dc20
92-35104   CIP   AC

Published in the United States by Lodestar Books,
an affiliate of Dutton Children's Books,
a division of Penguin Books USA Inc.,
375 Hudson Street, New York, New York 10014

Published simultaneously in Canada
by McClelland & Stewart, Toronto

Editor: Rosemary Brosnan   Designer: George Ancona
Printed in Hong Kong   First Edition   10 9 8 7 6 5 4 3 2 1

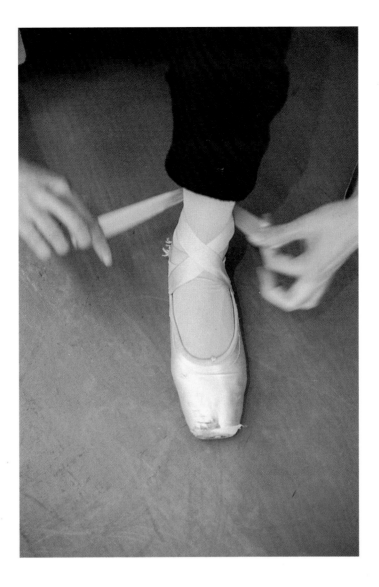

It is a hot June afternoon in bustling New York City. Pedestrians rush along the sidewalks, while taxi drivers honk their way through traffic, and buses screech to a halt. Amidst all of this urban confusion, two very slim, crisp-looking identical twins strut across famed Lincoln Center Plaza, oblivious to everything around them except their task at hand. They are headed for a theater where they intend to dance their hearts out for opening night of the School of American Ballet's Spring Workshop.

For the past ten years, Amy and Laurel Foster have trained their bodies and minds for this moment. They worked their way out of a small dance school in Atlanta, Georgia, and were chosen from more than three thousand other hopefuls to enroll at America's premier ballet school. After proving themselves during two summer sessions and then two full years, they have earned the reputation of being top-notch dancers.

Although they don't have principal roles in tonight's ballet, they feel confident that their solos will show off their talent. These performances are Amy and Laurel's big chance to dance, not only for talent scouts who have flown in from across the country, but for some of the great names in ballet as well: Mikhail Baryshnikov, Suzanne Farrell, Peter Martins. The evening promises high drama.

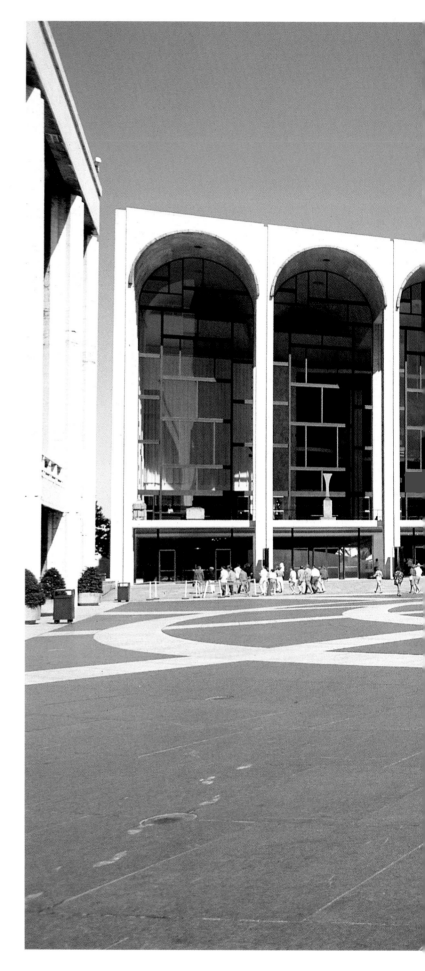

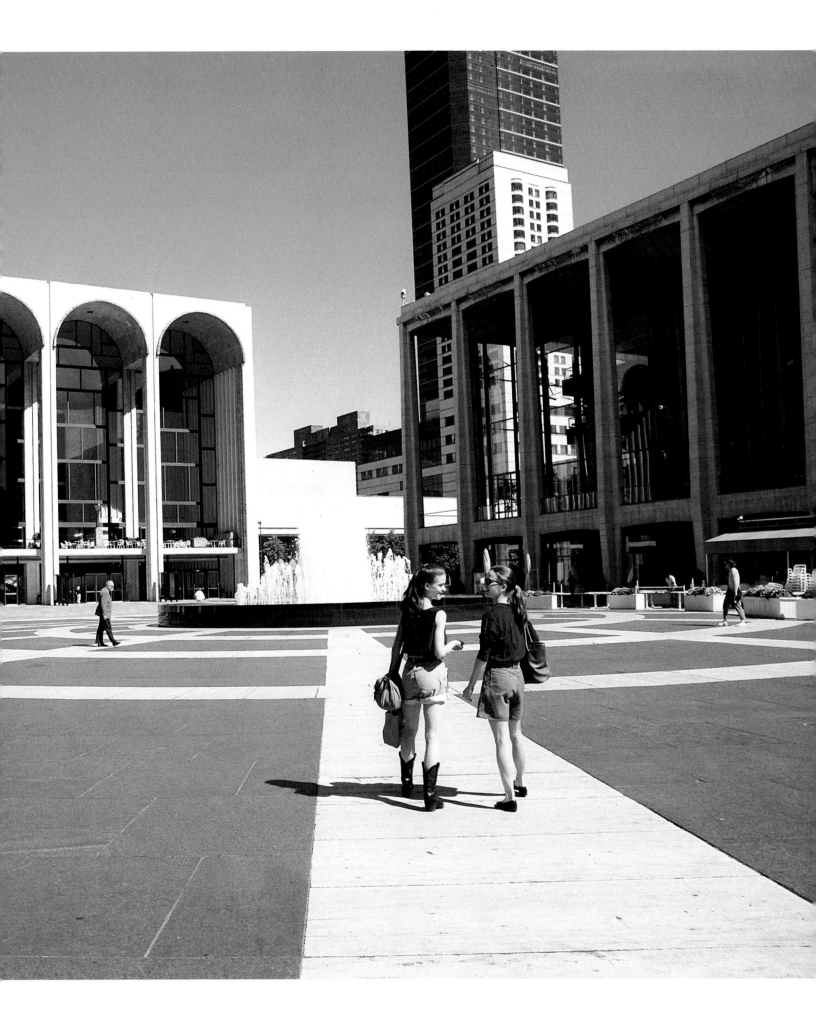

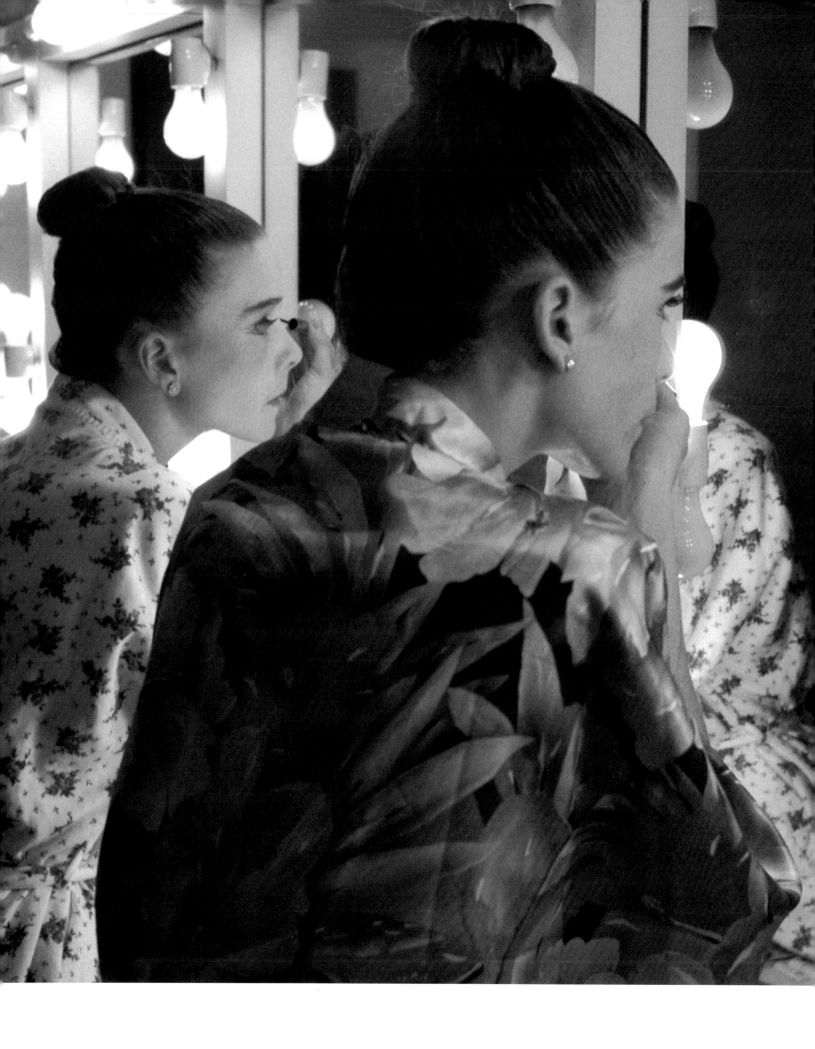

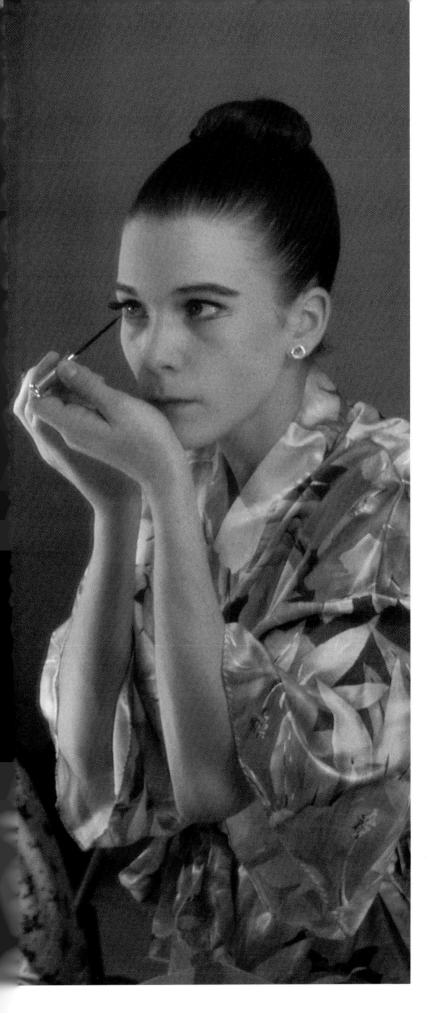

Approaching the side door of the Juilliard Theater, the twins make their way down two flights of stairs to dressing rooms, anxious now to prepare for what lies ahead. Behaving calmly and coolly, as if they were already seasoned performers, they take their places in front of brightly lit mirrors and begin applying makeup alongside fellow dancers. Like the twins, these dancers have managed to survive in a school where only 2 percent of the students actually become ballerinas. A serious air fills the tiny room. The School of American Ballet is interested only in turning out professional dancers, not coddling immature hopefuls.

There is a popular expression in the dance world: "Don't do it unless you have to." Amy and Laurel readily admit to their obsession. "There is nothing else we want to do," Amy says. "We live to dance."

They started taking jazz lessons at the Terpsichore Dance Center when they were seven years old. One day they tried a ballet class and in no time were hooked. Patsy Bromley, director of Terpsichore and a former student at the School of American Ballet, spotted the twins' talent. After that, their lives changed dramatically. "No more bike riding, or cheerleading, or social life," Laurel explains. "Each day after school, we headed for ballet classes, after which we went straight home for schoolwork and bed, repeating the same schedule day in and day out."

Now, ten years later, here they are, with false eyelashes and hair in chignons, realizing their dream.

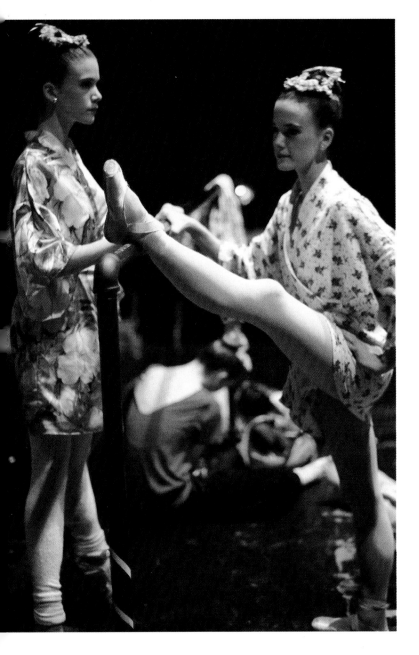

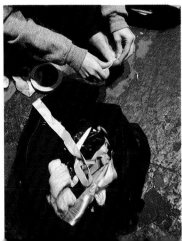

Backstage, dancers gradually appear, skimpily clad and ready to warm up. Laurel heads to the portable barre, where she begins a series of stretches. "I like to balance everything out before I dance, to make sure my entire body is warmed up," she says, her toes pointed pertly on top of the barre as she brings her head down to rest upon her knee. She keeps her leg warmers on till the very last moment so that her muscles don't tighten up.

Nearby, her sister Amy, who broke her ankle doing a pirouette a little over a year ago, pays special attention to her feet. She begins by sitting on the floor, legs stretched out in front of her, doing exercises with a wide elastic band to limber up her arches. Both girls allow thirty to forty-five minutes for conditioning before preparing their bruised and gnarled feet for pointe shoes.

"A lot of my confidence depends on my shoes," murmurs Amy, who puts masking tape on her blistered toes while her sister applies a cooling gel to numb hers. They stuff paper towels into the toes of their pink satin slippers to absorb the sweat. Then they slip their feet into their one and only prop. "Toe shoes are never comfortable," Amy says, "but they are the vehicle that allows us to come alive." She ties the satin ribbons, and up she goes, toddling around to test the fit. "Once I'm confident that I can feel what my feet are doing, I can forget about my shoes and focus on other things."

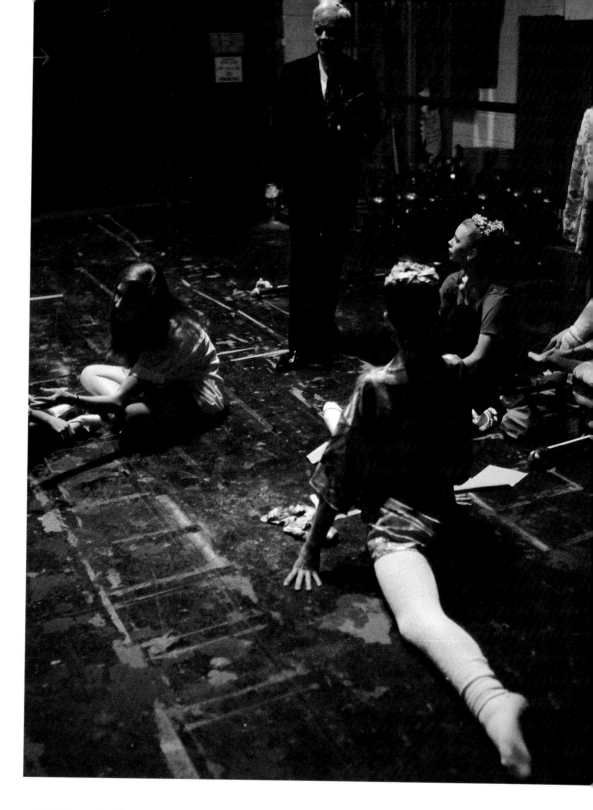

With a half hour left until curtain,
the twins don their tutus while teachers
meander about offering last-minute advice.
"When you get out there, have fun!" says
one. Another teacher is more specific.
"Make it big and juicy. When the curtain
goes up, I want bright cheery faces."

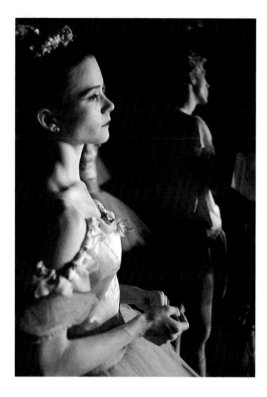

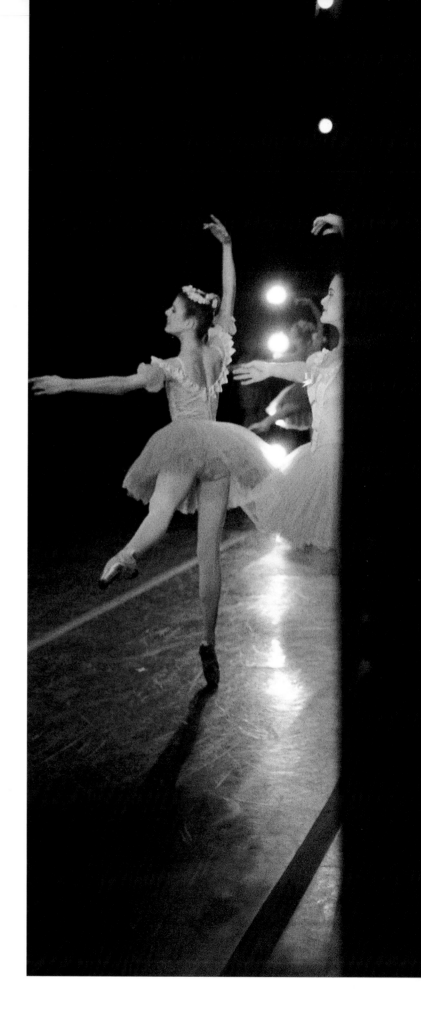

As the orchestra tunes up, Laurel and Amy take a few turns on the dimly lit stage before retiring to the wings. Accustomed to dancing in class to piano accompaniment, the twins are uplifted once they hear the first strains of the Mozart overture. Becoming part of the music is what ballet is all about. Amy and Laurel position themselves for their entrance, eager as racehorses at the starting gate. They left most of their nervousness in the dressing room and are now anxious to have fun.

Hearing their cue, they leap from the wings onto the stage, moving to the music, being drawn into it. They are quickly transformed from giddy teenagers into graceful swans. As they execute one perfect turn after another and create beautiful shapes with their bodies, the joy they feel about dancing is obvious. "I want the audience to have as much love and joy for what we are doing as we do," Amy often says.

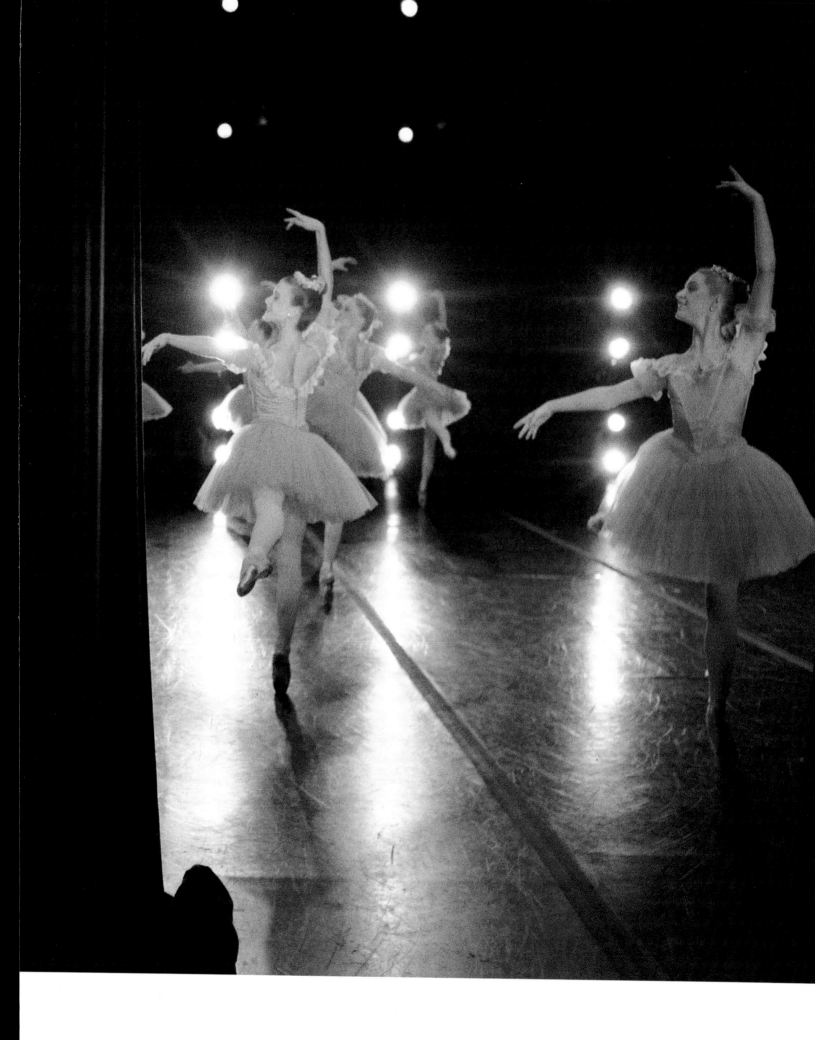

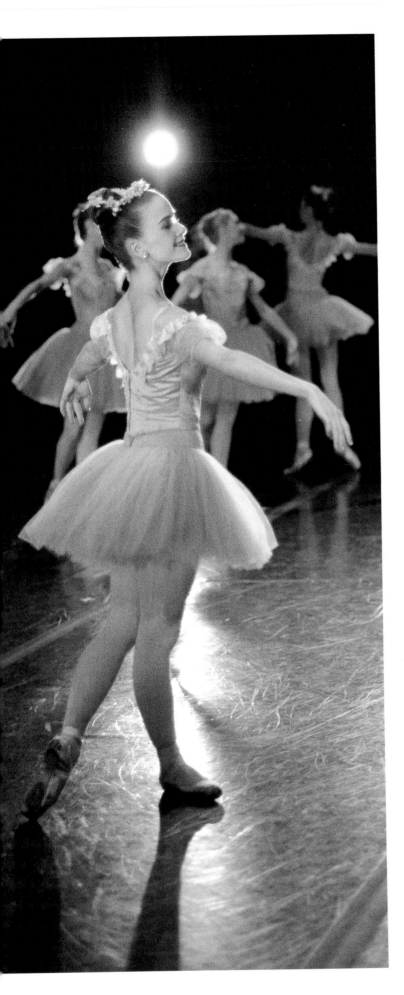

One thing is certain: They will not waste this showcase moment by doing just the minimum. One of their favorite teachers, Susie Pilarre, former soloist with the New York City Ballet, has trained them always to be big and exciting. "What are you saving yourselves for?" Susie asks her students daily. "Always dance as if it is the last thing you are going to do."

Throughout the ballet, members of the ensemble exit stage left with breathless sobs, sweat pouring down their foreheads. Within seconds they recover, anxiously awaiting their next entrances. They can't get enough of this stage magic. This is what they have been training for, and now that their chance has arrived, no one wants to miss a beat.

But all too soon the dancers hear the familiar strains of the finale. A few minutes later, the ballet is over. The teachers hurry onstage to congratulate their students.

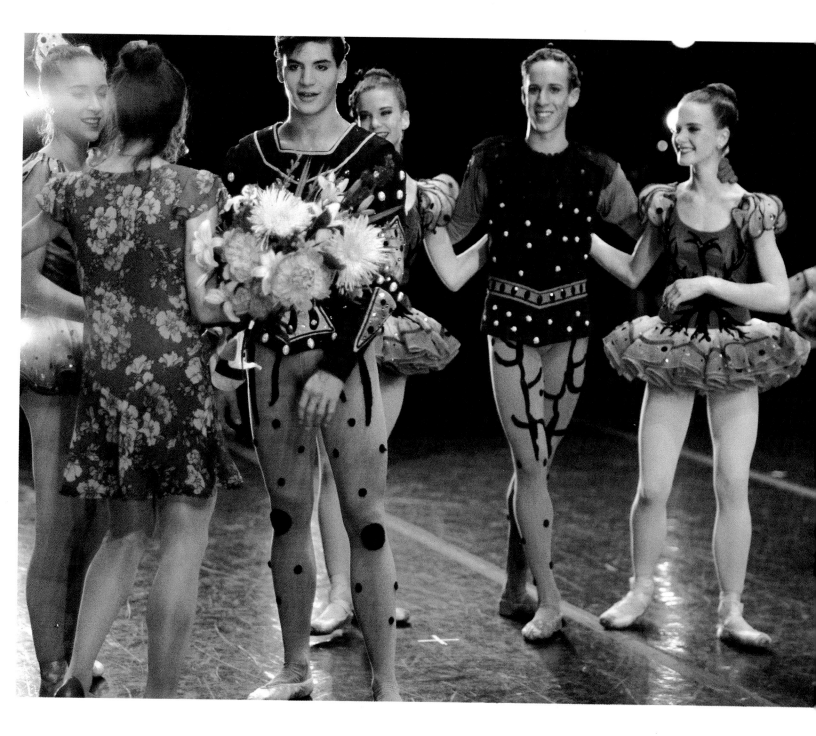

"Couldn't you feel how badly the audience wanted to be right up there onstage with you?" an excited Susie Pilarre asks her dancers, hugging each one. Laurel wonders if the late George Balanchine, founder of the school, would have been pleased with how they executed his choreography. Amy, on the other hand, wonders if they made any impression on Peter Martins, City Ballet's ballet-master-in-chief.

Once the curtain falls and the stage lights are dimmed, all that remains is the memory of young dancers who made few mistakes and rarely showed any strain. "We did exactly what we wanted to do," the twins say as they hug their parents.

How do these students dance in a way that seems so effortless? What struggles must they have endured?

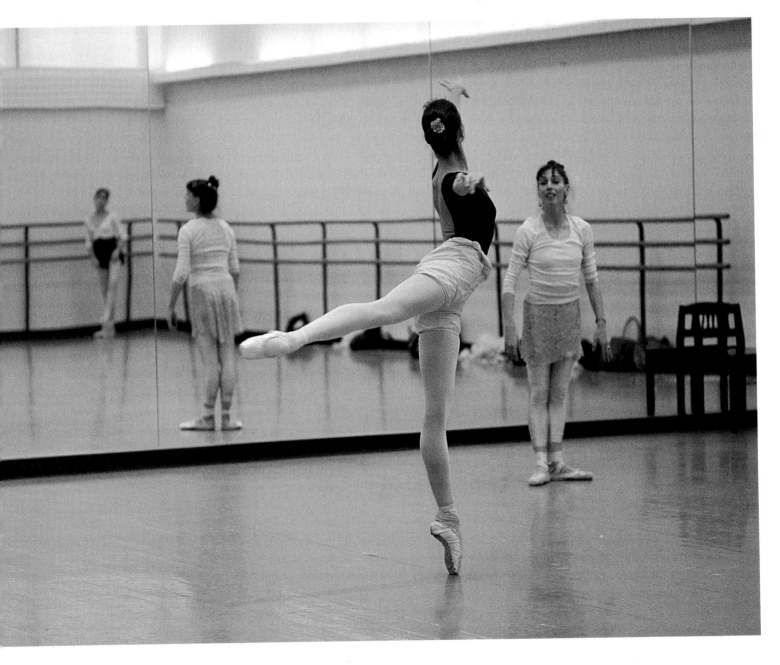

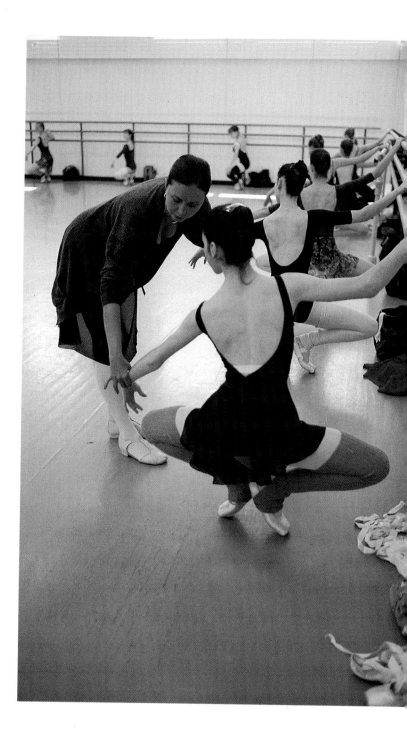

According to Nathalie Gleboff, director of the School of American Ballet, "All of these girls have been involved in an intense dance program since they were eight or nine years of age. They were thought to have potential because their hip joints are loose enough to make unnatural moves, and the arches of their feet are strong. In recent years," she continues, "the girls were lucky enough to have bodies that grew into the right shape. They demonstrated innate talent, discipline, and a passion for classical dance."

Once the girls arrive at the school, the faculty begins to correct bad habits and train the dancers to make the most of their strengths. When Amy and Laurel came to New York, they had developed sickle feet, which means that their feet pointed inward instead of straight, distorting the line of the foot. The teachers worked to point their feet the other way. But the twins also brought along certain assets. According to Ms. Pilarre, "They have a great sense of style. Their jazz background has made them more angular than flowery, which works well with Balanchine's choreography."

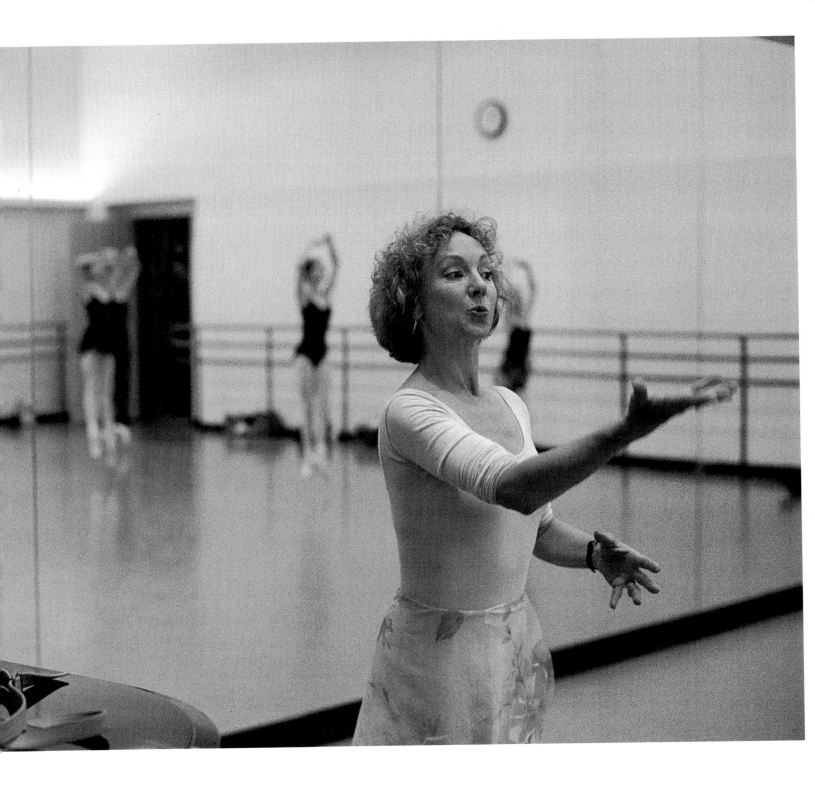

The mark of a serious dancer is someone who goes into the studio day after day to become better than she was yesterday. "It's hard to become extraordinary," says Susie Pilarre. "These kids have to work six days a week, pushing their bodies to extremes until the various positions feel normal."

Each morning from eight to nine-thirty, the twins attend Professional Children's School, where they take academic classes before reporting to the School of American Ballet for four to six hours of dance. Several times a week, they take technique class with Suki Schorer, former principal dancer with the New York City Ballet. In Suki's class, they work intricately at the barre. Like a doting mother, Suki moves around the studio, her sharp eye watching for finger positions, head tilts, angle of spines, and placement of feet. Sometimes she gets down on her hands and knees to fix feet or demonstrate with her own supple body what she wants her students to do. "Try not to teeter totter," she says to Laurel. "Your arms are the controls. Balance! Up . . . up . . . up!"

"We listen hard to criticism," explains Laurel. Eager to improve, the twins consider any comment a sign of approval. "A teacher's lack of interest can be more devastating than anything."

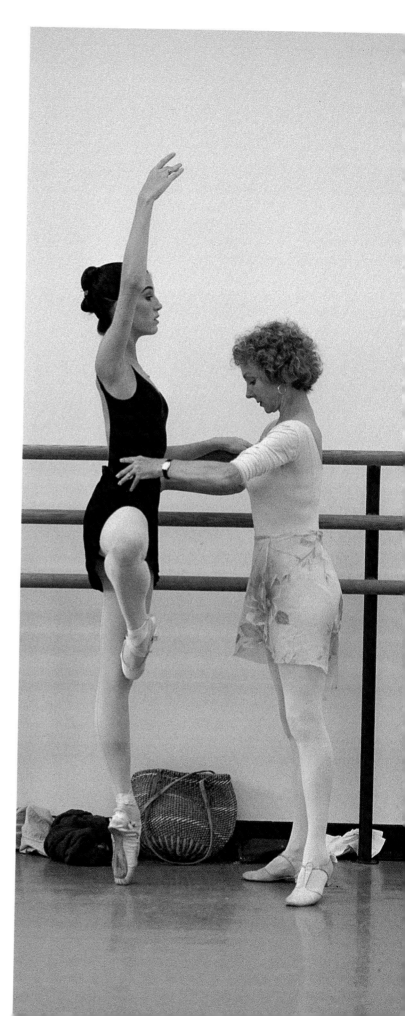

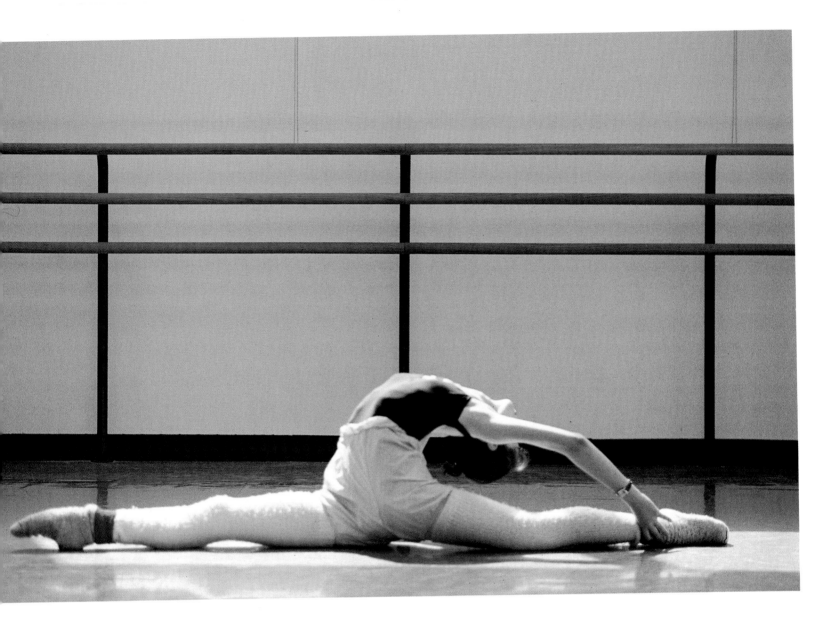

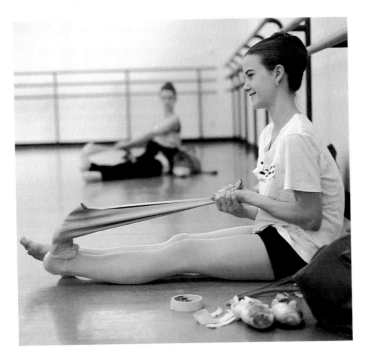

Praised by their teachers as hard-working, hard-driving dancers, the twins would never think of missing a class. "When we're home in Atlanta on vacation," Amy explains, "I might relax for a while, but then I need to get back to the studio. When we haven't danced for a few days, we feel lazy and slow."

"Besides," Laurel chimes in, "we need to never fall behind. Someone is always working just as hard beside us."

And so, some twelve hours after their curtain call, they are back at the barre, anxious to hear more about their performance and to see if they will be tapped by a company.

Streaks of early morning sunlight dot the bouncy, highly polished floor. The twins head for one of the warm spots, where they will stretch out to soothe their aching muscles. They gossip and chat with fellow dancers, who are already sprawled in catlike positions about the room. "Did you hear that Megan got into the company?" one girl says to Amy. The twins glance at each other, momentarily jealous, even though they suspected Megan would be first. Of all the girls in the advanced class, Megan has the most performance experience.

Laurel and Amy tiptoe out to dampen their toe shoes in the footbaths that line the gray-carpeted halls—and wonder if their chance will come. "There's always some stress," Amy says, shaking her head. "Either you get injured, or don't get a part that you knew you deserved, or just get overlooked." As her tired eyes fill up, the strains of a Brahms lullaby drift into the hall from the studio piano. As if on cue, the twins dart in to take their places at the barre.

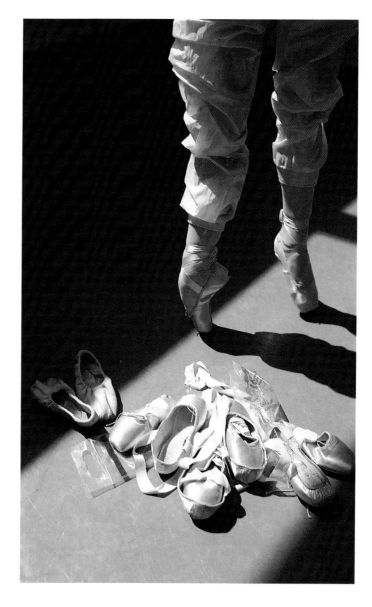

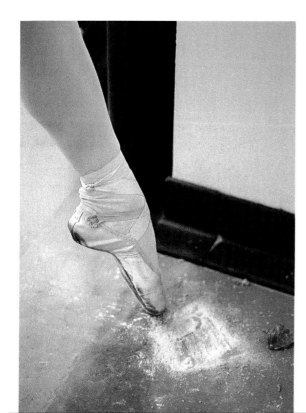

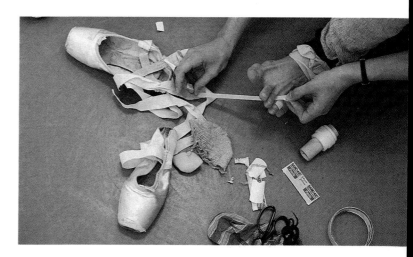

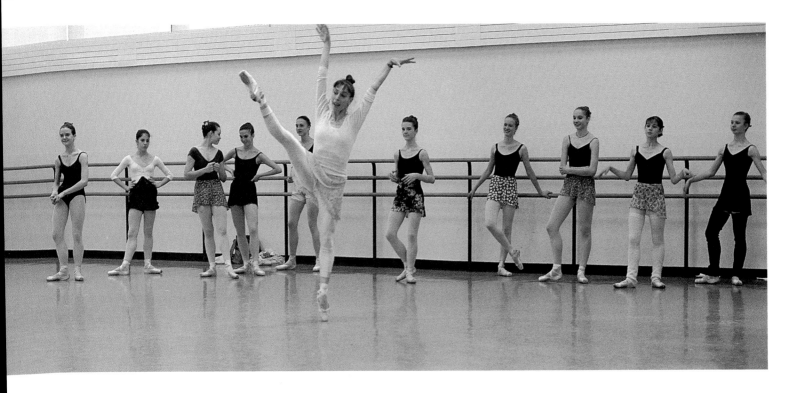

Susie Pilarre has swept into Studio 3 for this morning's variations class. Here dancers learn new steps and put them together in combinations.

Any lingering sign of the blues quickly dissolves as the twins cluster with the others at the back of the studio. Besides, teachers notice attitude. Being upbeat and positive are important characteristics for a dancer.

"I try to instill challenge into the girls," Susie says, "to propel them forward. Balanchine had incredible energy and he put that in his dancers. I try to do the same."

Learning variations takes concentration and a keen memory. The girls must interpret steps as soon as they are given. Using their hands, they mark what their feet will be doing as they walk through a combination. Susie dances in front of them to illustrate the more difficult moves.

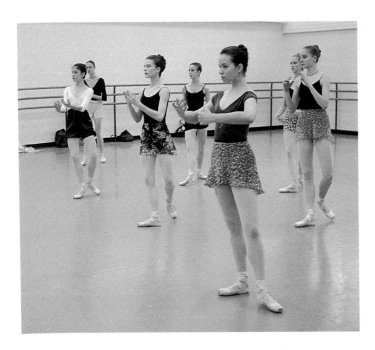

"Practice one turn, then another," she says quietly, patiently. "Then we'll put it together."

Streaks of early morning sunlight dot the bouncy, highly polished floor. The twins head for one of the warm spots, where they will stretch out to soothe their aching muscles. They gossip and chat with fellow dancers, who are already sprawled in catlike positions about the room. "Did you hear that Megan got into the company?" one girl says to Amy. The twins glance at each other, momentarily jealous, even though they suspected Megan would be first. Of all the girls in the advanced class, Megan has the most performance experience.

Laurel and Amy tiptoe out to dampen their toe shoes in the footbaths that line the gray-carpeted halls—and wonder if their chance will come. "There's always some stress," Amy says, shaking her head. "Either you get injured, or don't get a part that you knew you deserved, or just get overlooked." As her tired eyes fill up, the strains of a Brahms lullaby drift into the hall from the studio piano. As if on cue, the twins dart in to take their places at the barre.

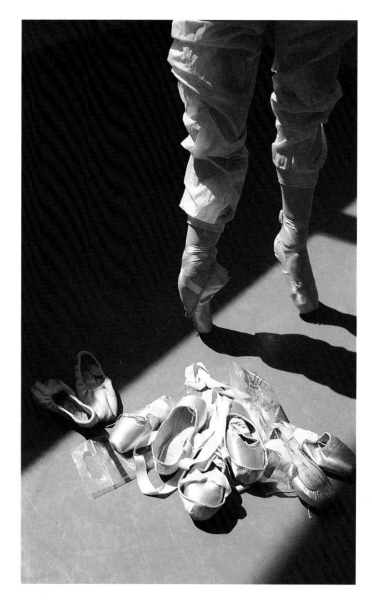

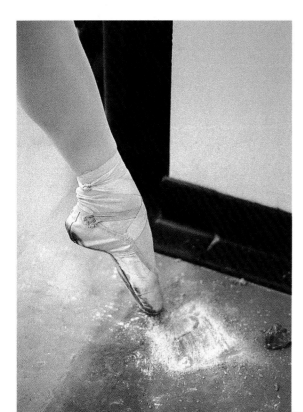

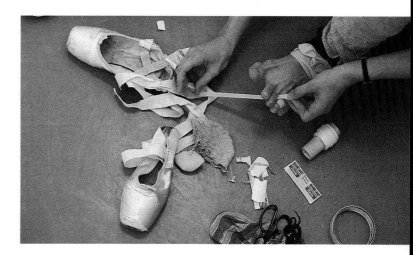

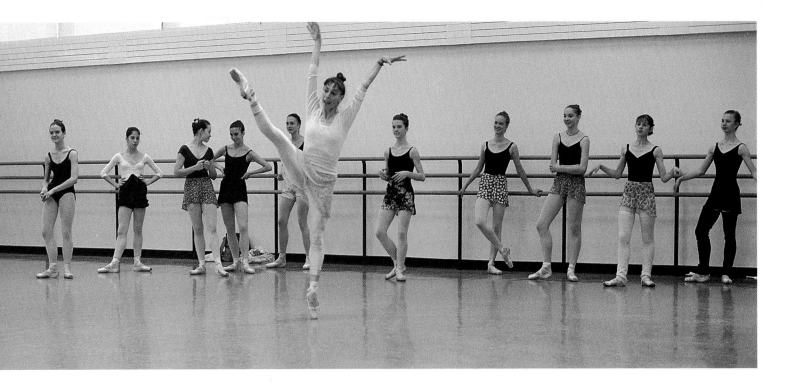

Susie Pilarre has swept into Studio 3 for this morning's variations class. Here dancers learn new steps and put them together in combinations.

Any lingering sign of the blues quickly dissolves as the twins cluster with the others at the back of the studio. Besides, teachers notice attitude. Being upbeat and positive are important characteristics for a dancer.

"I try to instill challenge into the girls," Susie says, "to propel them forward. Balanchine had incredible energy and he put that in his dancers. I try to do the same."

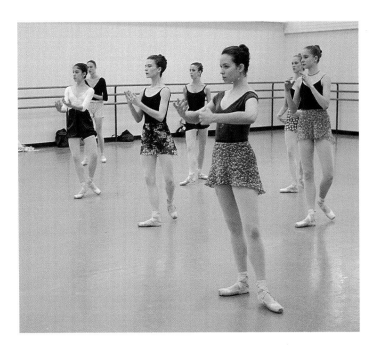

Learning variations takes concentration and a keen memory. The girls must interpret steps as soon as they are given. Using their hands, they mark what their feet will be doing as they walk through a combination. Susie dances in front of them to illustrate the more difficult moves.

"Practice one turn, then another," she says quietly, patiently. "Then we'll put it together."

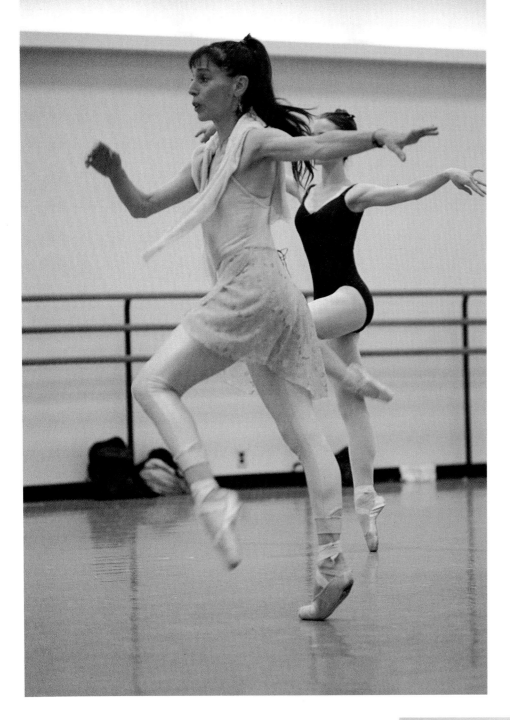

Meanwhile, the pianist, Alla Edwards, watches carefully from her corner of the studio, where she sits at the baby grand piano. Once she understands what they are trying to achieve, she begins playing—sometimes classical music, sometimes movie themes, sometimes songs from the Beatles—whatever is needed to fit the mood of the movement.

For the next hour, the room becomes a kaleidoscope of patterns.

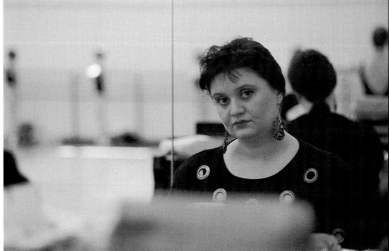

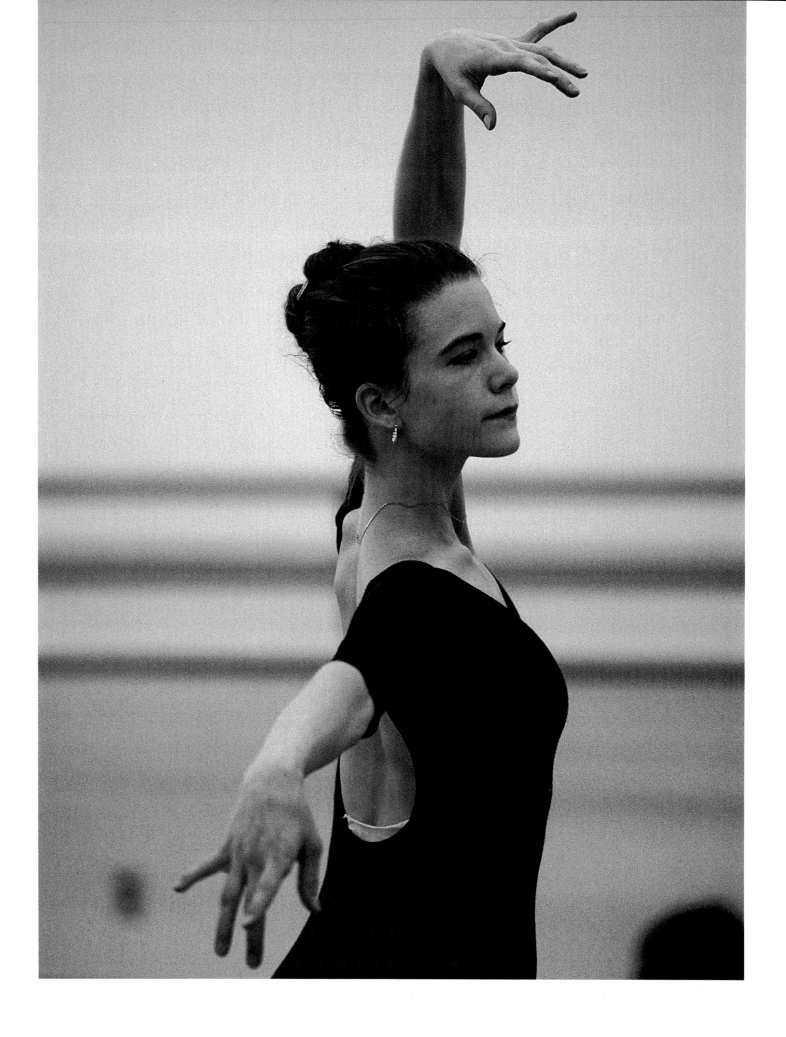

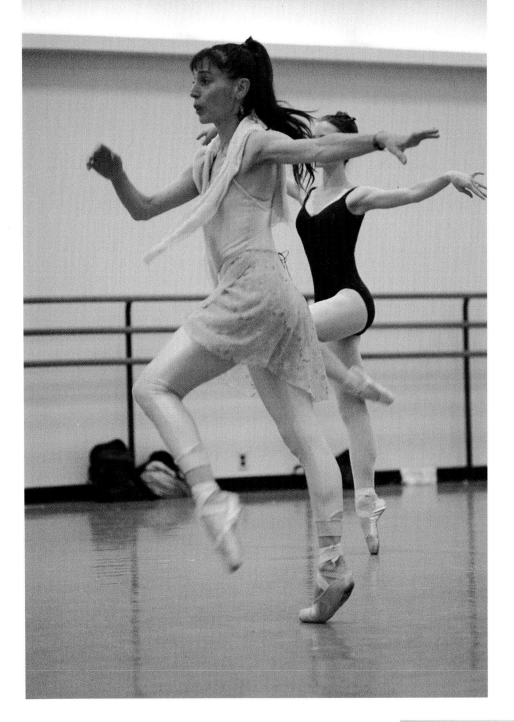

Meanwhile, the pianist, Alla Edwards, watches carefully from her corner of the studio, where she sits at the baby grand piano. Once she understands what they are trying to achieve, she begins playing—sometimes classical music, sometimes movie themes, sometimes songs from the Beatles—whatever is needed to fit the mood of the movement.

For the next hour, the room becomes a kaleidoscope of patterns.

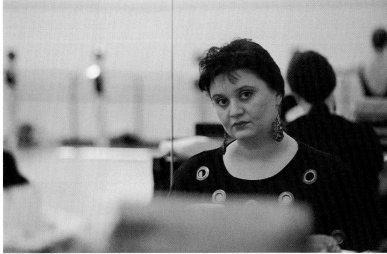

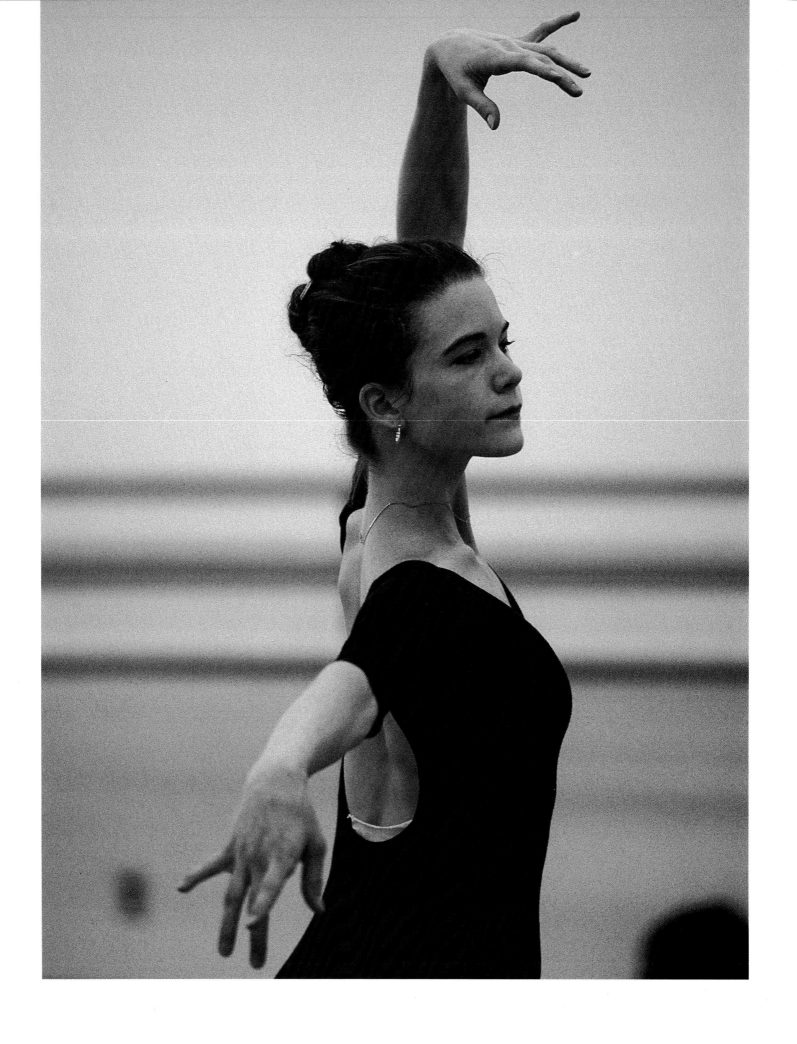

But always as they dance, the twins check themselves in the mirror that lines the front of the studio. They know that it never lies. Trained to watch themselves, they get frustrated when they make an awkward move or their bodies droop into sloppy form. "We see what an audience will see," Amy says, momentarily disgusted with a badly executed combination. She lingers at the mirror to perfect her last turn, demonstrating tremendous conviction.

"I look for lines," Amy says, "the lines of my body and position. I'm always checking to see if my feet are pointed and my shoulders are down."

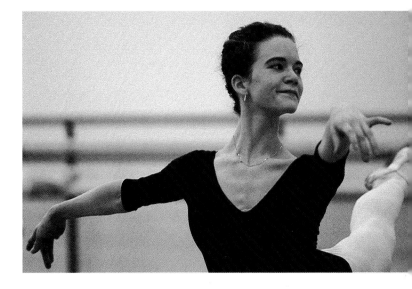

Their craft is a self-challenging art. At this late stage of development, no one is pushing them but themselves. Balanchine himself strongly opposed giving diplomas at his school. "A dancer never completes her development," he said. "Diplomas might imply limits."

"In the end we are individuals, dancing for ourselves," the twins say. As they work their muscles and minds and will, it is apparent that every step they take is a continual struggle to improve, to achieve mastery over their own bodies.

In between classes, the twins head for a lounging area where fellow students congregate. Today the tension is high, as several receive news of what their future holds.

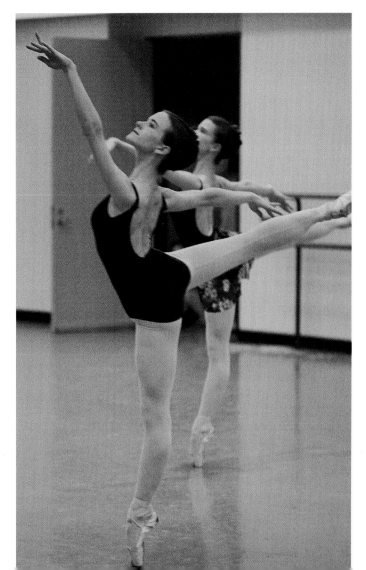

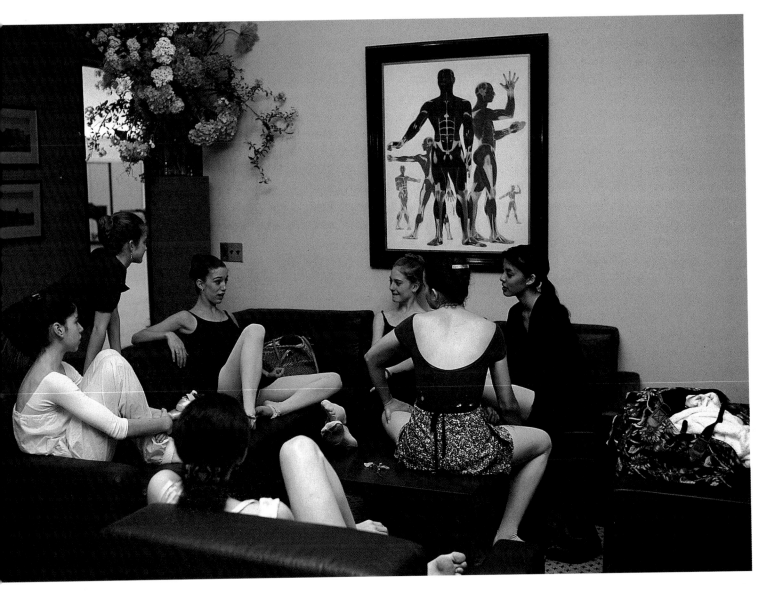

A teary blonde, slouched alone in a corner, has just been encouraged to take an offer from a company in Seattle. Her chances of getting into the New York City Ballet are nil. Nearby, a boy has just signed a contract with the American Ballet Theatre, and a teacher is challenging his decision. Five or six dancers, huddled on the couch, wait for a newspaper review, hoping to spot one of their names. Amy and Laurel stand apart from the others, looking tense and tired.

Nevertheless, as if fueled by the competition, they seem impatient to get into their next class. "Rejection is only going to make

us work harder," Laurel says, happy to be entering Stanley Williams' class. "Stanley seems to really care about us," she says wistfully. Formerly of the Royal Danish Ballet, Mr. Williams is almost spiritual about his teaching. "I have a certain purpose with every step," he says, as the music casts a soft, velvety spell over the studio, and he tiptoes about, raising and lowering his arms, his fingers clicking to the beat of the piano.

"Get up there . . . up, up," he urges Amy, stretching right along with her. And then he bends down to push Laurel's instep out just a bit more, whispering sympathetically, "I know it's so hard." His finger slides down her leg like a feather, and he taps the small of her back as if his arm were a wand.

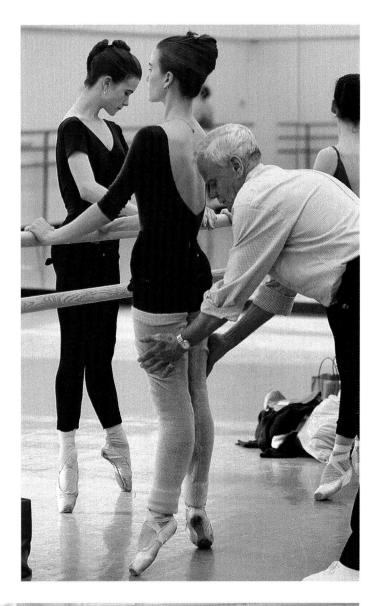

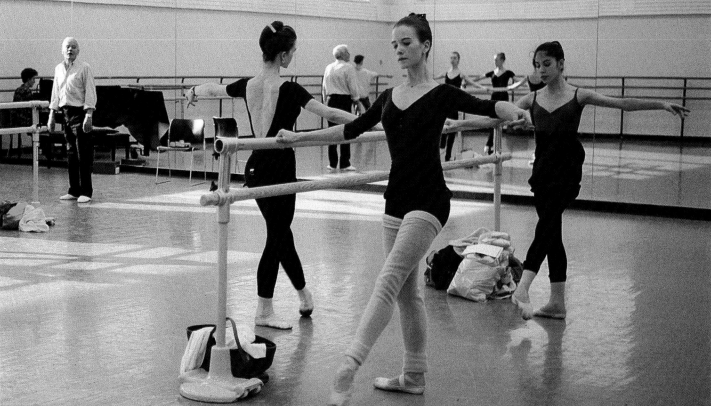

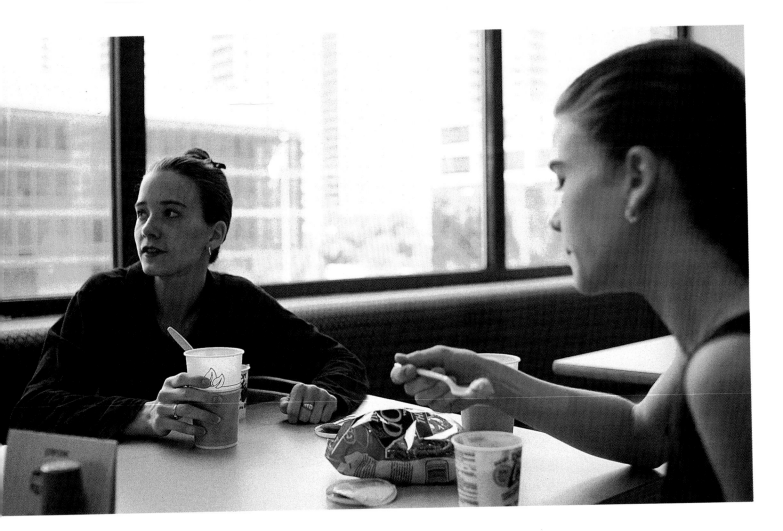

An hour and a half later, the girls mop their brows and head for the school cafeteria. As they fine tune their bodies in class, so they must care for their instrument by eating right.

Lunch usually consists of yogurt, fruit, and juice. "We need to keep our liquid and natural sugar intake up during the day," Amy says. "But we can't eat too much. It would only get in the way of our dancing." In the evening, back in their apartment, they have a heavier meal of protein and carbohydrates.

As their muscles relax and the performer's mask comes off, the twins gaze dreamily out the window toward Lincoln Center, where the New York City Ballet performs. "Our first choice for a company is City Ballet," Laurel

says. "After all, both our school and City Ballet were founded by Balanchine. We've been trained to dance his way," she continues, referring to the vigorous pace and expansive style that characterize Balanchine choreography.

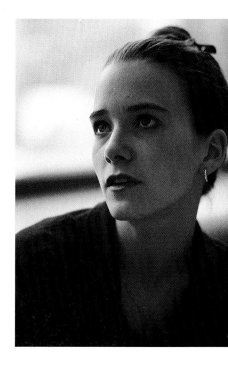

"But we'll take another company," Amy chimes in, poking her sister. The twins have been told by several teachers that they simply aren't students anymore. "Stanley says we need to get out there and perform," Amy says, "and the suspense is killing us!" They have received a letter of interest from Edward Villella, the artistic director of the Miami City Ballet, but so far no contract.

"Hey, we've got two more performances," Laurel says, quieting her sister's negativity.

It seems that when one twin is up, the other is down. In a world in which few openings exist for much talent, the tendency among dancers is to keep strategies and insecurities to oneself. Laurel and Amy are lucky to have someone in whom they can confide . . . and whom they can prod! "Look at the clock," Laurel says to Amy. "We're late for Tumey's class."

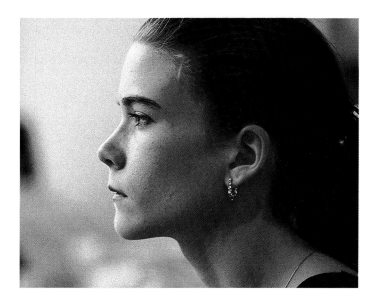

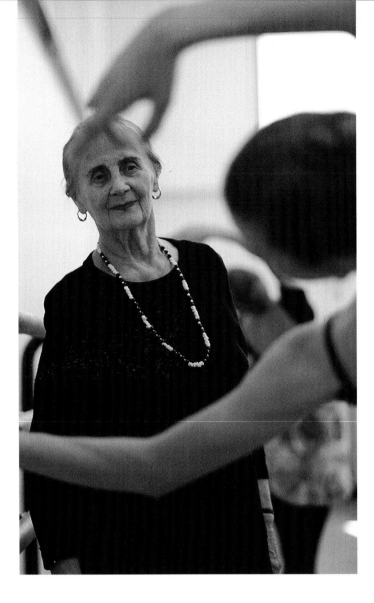

"If you can survive Tumey's class, you can do anything," Laurel says as the tiny Russian-trained Antonina Tumkovsky, who has been teaching strict classicism at the school for forty years, enters the studio. Dressed in black, save for her pink T-strap shoes, she smiles briefly, and, without skipping a beat, begins. "One, tuh . . ." She winds her way around the girls, missing nothing. "She pays a lot of attention to arms," Amy says, "because with the arms and back a dancer presents herself." The twins need work on their arms and welcome her criticism . . . to a point.

"Tumey's classes are relentless," Laurel explains. "Members of the company, who frequently take classes here, will never take a Tumey class. She wants everything perfect. One tiny mistake and you do it again

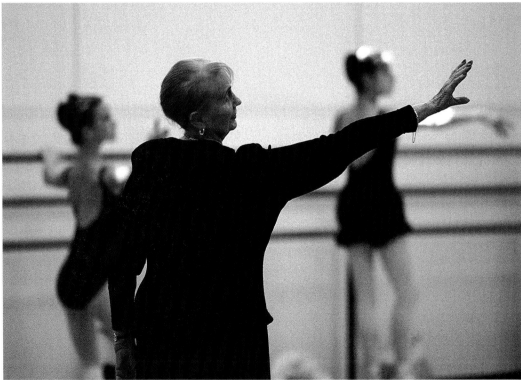

and again. Still, I have to admit I love her combinations—that is, if you can understand them." Tumey spits out commands in a mixture of Russian, French, and a bit of English.

Perspiration quickly collects on the dancers' foreheads and chests, and gasps blend in with the sound of scraping toe shoes. With another workshop performance just hours away, the twins had hoped that class wouldn't be too rigorous. But Tumey doesn't think of such things. She insists that if you can't do class, then you must not be able to perform.

Still, there is a round of applause for Tumey at the end of class before the twins collapse on the floor. "My muscles just gave out," Amy grumbles. "But I think I'm still alive."

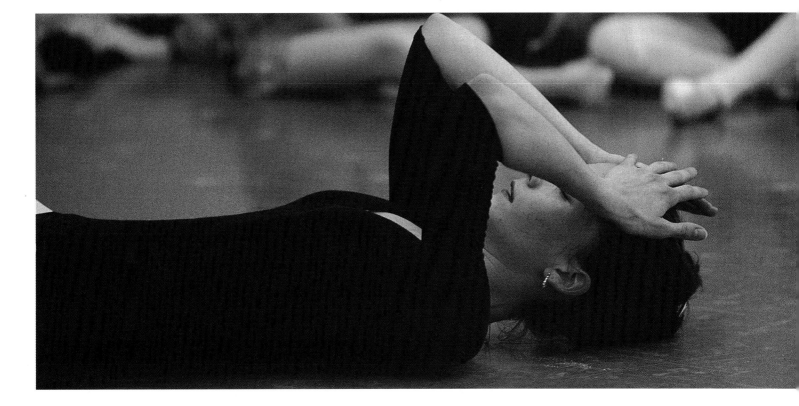

Although they are exhausted tonight, the twins seem exhilarated. In their costumes, they stand ready to perform, deriving their stamina and strength from each other.

George Balanchine once described the way to become a successful ballerina: "You have to listen, you have to want it. Be starving."

Both Laurel and Amy are hungry and are ready to feast. Besides, they *have* to dance. It is all they have ever wanted to do. "There is no justice in ballet school or the ballet world," Laurel says. "We know that going in. But we also know that we are good. We have no interest in being stuck in the back row corps of some company. We want to be challenged and to put our skills to use."

"There's going to be a day when all our hard work will pay off," Amy says. "But the clock is ticking. Our time is here—now!"

With that, they recognize Stravinsky's Overture for *Danses Concertantes,* listen for their cue, go on pointe, and float toward the footlights.

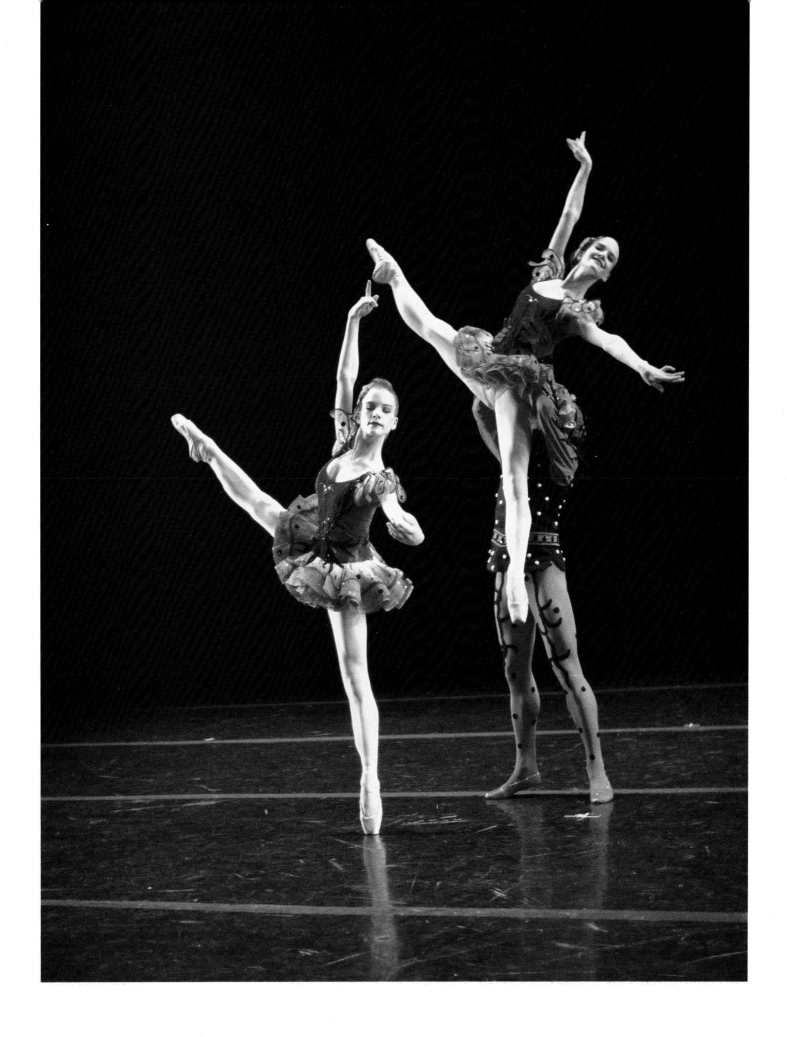

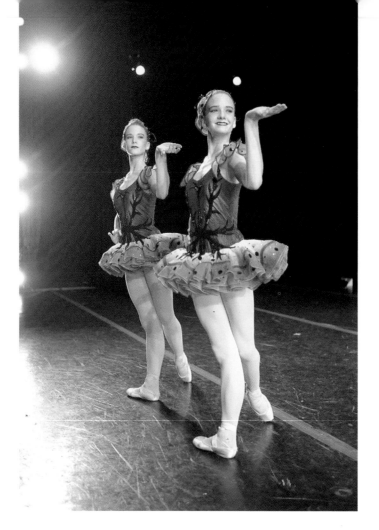

### Afterword

A few days after Spring Workshop, the Foster twins signed a contract with the Miami City Ballet. They are honored and thrilled because the artistic director, Edward Villella, was for many years a principal dancer for the New York City Ballet. Encouraged to sign on by Stanley Williams, who had Villella as a student, the twins did just that, heading for Miami almost immediately. They are privileged to have contracts and to be spared the apprenticeship route many of their fellow students must take before joining a company. "We will be learning senior corps parts for *Serenade* and *Concerto Barocco,*" they say, hoping to escape the back row corps altogether. "In the end, we are individuals dancing for ourselves," the twins have said, and so they are.